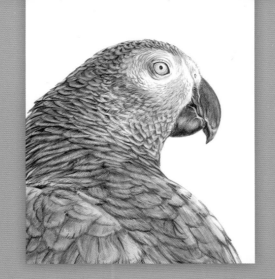

BIRDS

By choosing to draw birds, you'll find never-ending variety to explore with your pencil. The only thing as diverse as the birds themselves is the range of possibilities in how to draw them. By dispensing with color and using a grayscale approach with pencil drawings, you have the opportunity to explore the fundamentals of avian design, focusing your efforts on the values, patterns, and textures of your feathered models. In this book I will show you how to create the basic shapes that give different birds in various habitats and poses their form. Then, through a series of steps, I will help you bring them to life with simple drawing tools and a variety of techniques. Using my notes as a guide, you can render your creations in a way that suits your own style. As you put on the finishing touches, enjoy drawing with a realism that leaves the birds on the page watching you, and ready to fly off the paper. —*Maury Aaseng*

CONTENTS

TOOLS & MATERIALS

Graphite pencil artwork requires few supplies, and fortunately they are fairly inexpensive. Choose professional pencils and paper, rather than student-grade materials; they will last longer and ensure a higher-quality presentation.

Pencils

Pencils are labeled based on their lead texture. Hard leads (H) are light in value and great for fine, detailed work, but they are more difficult to erase. Soft leads (B) are darker and wonderful for blending and shading, but they smudge easily. Medium leads, such as HB and F, are somewhere in the middle. Select a range of pencils between HB and 6B for variety. You can purchase wood-encased pencils or mechanical pencils with lead refills.

Wooden Pencil The most common type of pencil is wood-encased graphite. These thin rods—most often round or hexagonal when cut crosswise—are inexpensive, easy to control and sharpen, and readily available to artists.

Flat Carpenter's Pencil Some artists prefer using a flat carpenter's pencil, which has a rectangular body and lead. The thick lead allows you to easily customize its shape to create both thick and thin lines.

Mechanical Pencil Mechanical pencils are plastic or metal barrels that hold individual leads. Some artists prefer the consistent feel of mechanical pencils to that of wooden pencils; the weight and length do not change over time, unlike wooden pencils that wear down with use.

Woodless Graphite Pencil These tools are shaped like wooden pencils but are made up entirely of graphite lead. The large cone of graphite allows artists to use either the broad side for shading large areas or the tip for finer strokes and details.

Graphite Stick Available in a full range of hardnesses, these long, rectangular bars of graphite are great tools for sketching (using the end) and blocking in large areas of tone (using the broad side).

Carpenter's Pencil

Mechanical Pencil

Woodless Pencil

Graphite Stick

Paper

Paper has a tooth, or texture, that holds graphite. Papers with more tooth have a rougher texture and hold more graphite, which allows you to create darker values. Smoother paper has less tooth and holds less graphite, but it allows you to create much finer detail. Plan ahead when beginning a new piece, and select paper that lends itself to the textures in your drawing subject.

Blending Tools

There are several tools you can use to blend graphite for a smooth look. The most popular blenders are blending stumps, tortillons, and chamois cloths. Never use your finger to blend—it can leave oils on your paper, which will show after applying graphite.

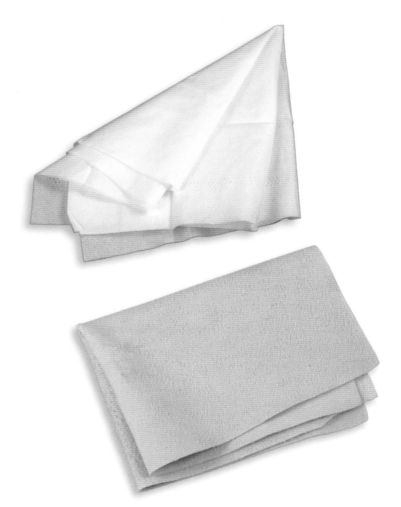

Stumps Stumps are tightly rolled paper with points on both ends. They come in various sizes and are used to blend large and small areas of graphite, depending on the size of the stump. You can also use stumps dipped in graphite shavings for drawing or shading.

Tortillons Tortillons are rolled more loosely than a stump. They are hollow and have one pointed end. Tortillons also come in various sizes and can be used to blend smaller areas of graphite.

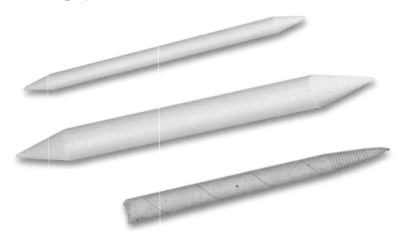

Facial Tissue Wrap tissue around your finger or roll it into a point to blend when drawing very smooth surfaces. Make sure you use plain facial tissue, without added moisturizer.

Chamois Chamois are great for blending areas into a soft tone. These cloths can be used for large areas or folded into a point for smaller areas. When the chamois becomes embedded with graphite, simply throw it into the washer or wash by hand. Keep one with graphite on it to create large areas of light shading. To create darker areas of shading, add graphite shavings to the chamois.

Erasers

Erasers serve two purposes: to eliminate unwanted graphite and to "draw" within existing graphite. There are many different types of erasers available.

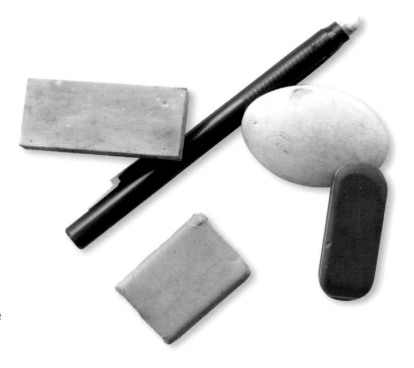

Kneaded This versatile eraser can be molded into a fine point, a knife-edge, or a larger flat or rounded surface. It removes graphite gently from the paper but not as well as vinyl or plastic erasers.

Block Eraser A plastic block eraser is fairly soft, removes graphite well, and is very easy on your paper. Use it primarily for erasing large areas, but it also works quite well for doing a final cleanup of a finished drawing.

Stick Eraser Also called "pencil erasers," these handy tools hold a cylindrical eraser inside. You can use them to erase areas where a larger eraser will not work. Using a utility razor blade, you can trim the tip at an angle or cut a fine point to create thin white lines in graphite. It's like drawing with your eraser!

BASIC TECHNIQUES

The key to transforming flat, simple shapes into convincing, lifelike forms is employing a variety of shading techniques. These contrasts in value (the relative lightness or darkness of a color or of black) are what give depth and form to your drawings.

Creating Depth Separating the dark values of your shading from the light areas and highlights of your drawing helps produce a sense of depth and volume. When creating highlights, you can either "save" the white of the paper by leaving areas of the paper white, or you can "retrieve" highlights by pulling out the value—removing graphite from the paper using the edge of a kneaded eraser that has been formed to a point. Value tells us more about a form than its outline does, so use a variety of techniques to create a range of shades and highlights.

Seeing Values This value scale shows the gradation from black—the darkest value—through various shades of gray, ending with white—the lightest value.

Shape

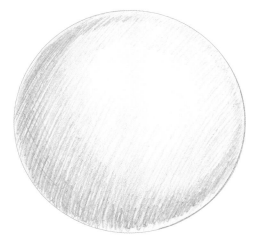

Form

Shading to Create Form Shading must be added to create the illusion of depth. The plain circle to the left is simply a flat disk; but adding shading gives it form, creating a three-dimensional sphere.

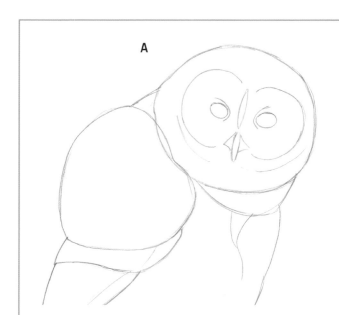

A

B

BLOCKING IN SHAPES

Start by blocking in the most basic shapes (A). These shapes create guidelines as you start to develop the details (B).

Practicing Basic Techniques By studying the basic shading techniques below, you can learn to render smooth beaks, piercing eyes, different types of feathers, and simple backgrounds. Whatever techniques you use, though, remember to shade evenly. Shading in a mechanical side-to-side direction, with each stroke ending below the last, can create unwanted bands of tone throughout the shaded area. Instead try shading evenly, in a back-and-forth motion over the same area, varying the spot where the pencil point changes direction.

Hatching Hatching is a shading technique in which you make a series of parallel strokes placed closely together.

Crosshatching Crosshatching is a shading technique in which you make a series of crisscrossed hatching strokes.

Gradating To create graduated values (from dark to light), apply heavy pressure with the side of your pencil, gradually lightening the pressure as you stroke.

Blending To smooth out the transitions between strokes and create a dark, solid tone, gently rub the lines with a blending stump or tissue.

PENCIL STROKES

Learning to draw requires a certain amount of control and precision, so get used to the feel of a pencil in your hand and the kinds of strokes you can achieve. Before you begin sketching, experiment with different pencil grips to see how they affect the lines you produce. Fine detail work is more easily accomplished with a sharp pencil held as though you were writing, whereas shading is best done with the side of your pencil, holding it in an underhand position. Practice holding the pencil underhand, overhand, and in a writing position to see the different lines you can create. You can also vary your strokes by experimenting with the sharpness or dullness of your pencil points. A sharp point is good for keeping your drawings detailed and refined; the harder the lead, the longer your pencil point remains sharp and clean. A flat point or chisel point is helpful for creating a wider stroke, which can quickly fill larger areas. Create a flat or chisel point by rubbing the sides of a pencil on a sandpaper block or even on a separate sheet of paper.

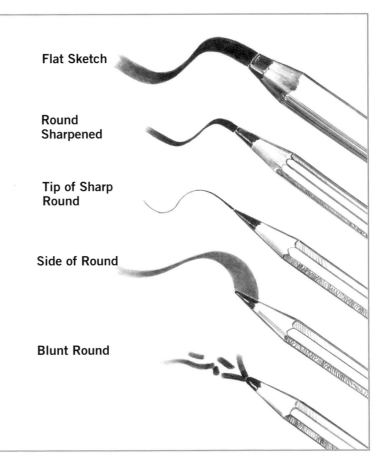

Flat Sketch

Round Sharpened

Tip of Sharp Round

Side of Round

Blunt Round

BARRED OWL

I think owls are mysterious, and I wanted to draw one that is hunched, silently turning its head to focus on the viewer. The slightly cocked head makes me think the large night bird is thinking while it watches. This photo captures the basic pose I want to render, but I decide to perch my owl on a high tree snag with a simple background.

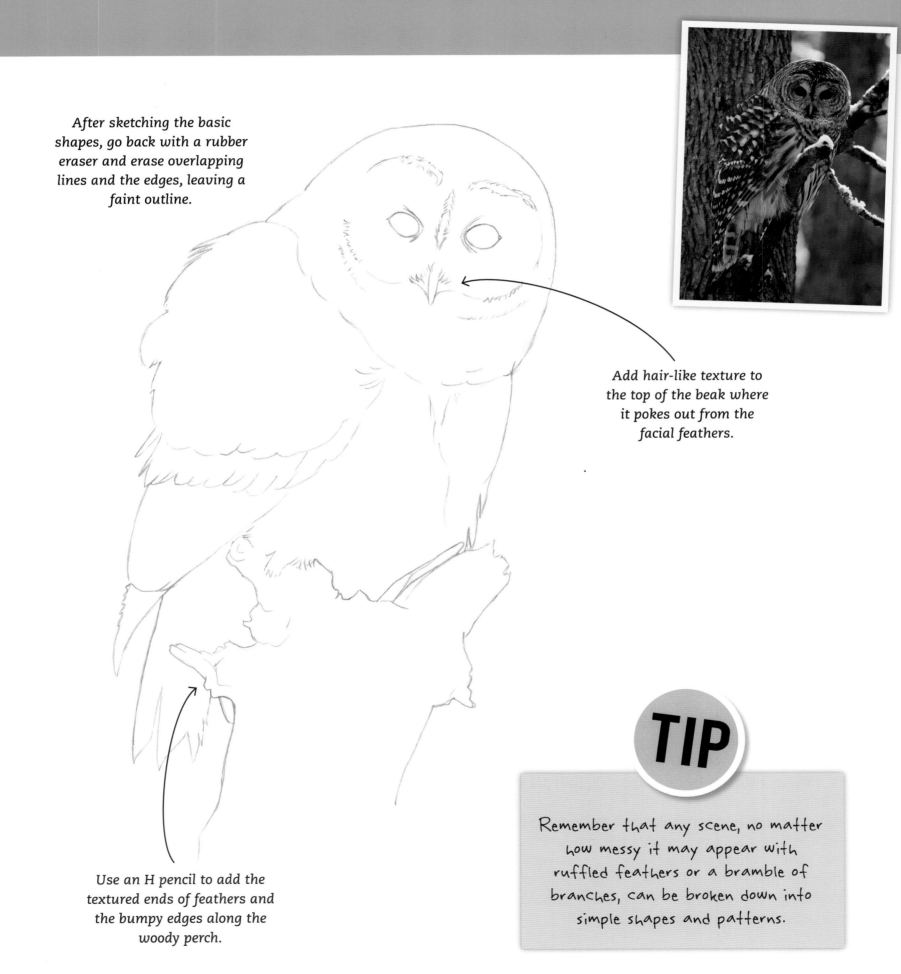

After sketching the basic shapes, go back with a rubber eraser and erase overlapping lines and the edges, leaving a faint outline.

Add hair-like texture to the top of the beak where it pokes out from the facial feathers.

Use an H pencil to add the textured ends of feathers and the bumpy edges along the woody perch.

TIP

Remember that any scene, no matter how messy it may appear with ruffled feathers or a bramble of branches, can be broken down into simple shapes and patterns.

Use a 2B soft graphite pencil to fill the eyes. Switch to a lighter 2H pencil and add texture to the feathers on the beak and between the eyes. Shade in the feathers on the top of the head, leaving occasional white patches.

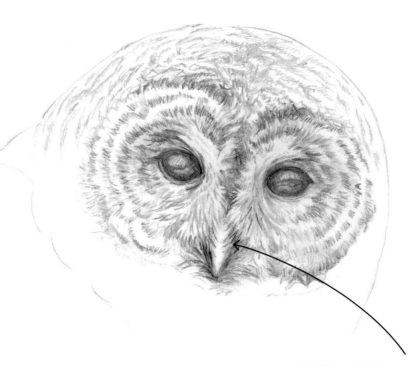

With an HB pencil, go around the beak with light strokes for hair-like feathers. Then draw the dark circles surrounding the eyes and the vertical bar between them.

Use a blending stump to pull some of the graphite into the neck. Map out more feathers with a 2H pencil and start adding dark values around the head with a B pencil.

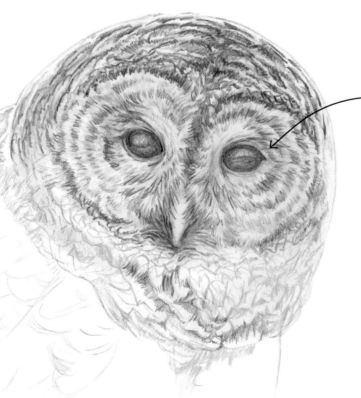

Use a blending stump to subtly shade gray into the discs around the eyes, especially on each side of the eye, to ground them within the feathers.

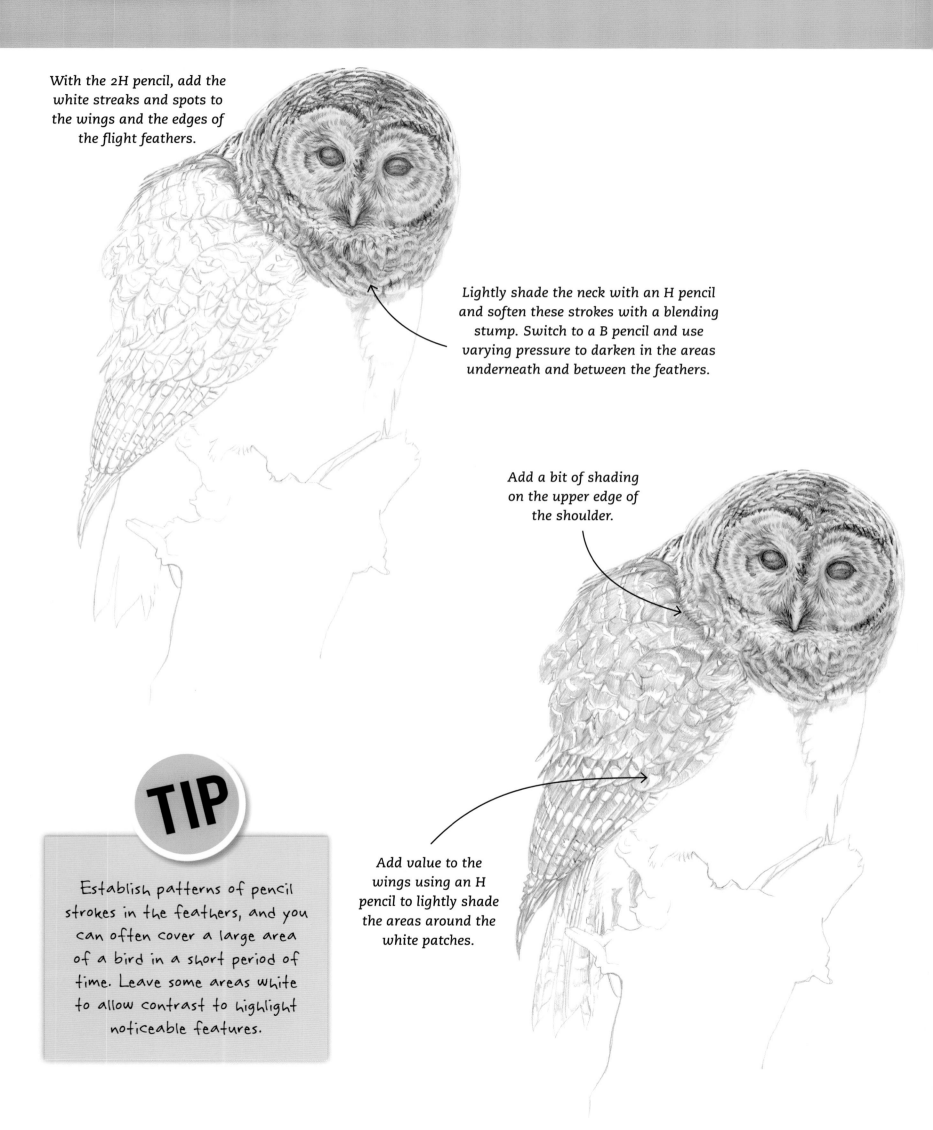

With the 2H pencil, add the white streaks and spots to the wings and the edges of the flight feathers.

Lightly shade the neck with an H pencil and soften these strokes with a blending stump. Switch to a B pencil and use varying pressure to darken in the areas underneath and between the feathers.

Add a bit of shading on the upper edge of the shoulder.

Add value to the wings using an H pencil to lightly shade the areas around the white patches.

TIP

Establish patterns of pencil strokes in the feathers, and you can often cover a large area of a bird in a short period of time. Leave some areas white to allow contrast to highlight noticeable features.

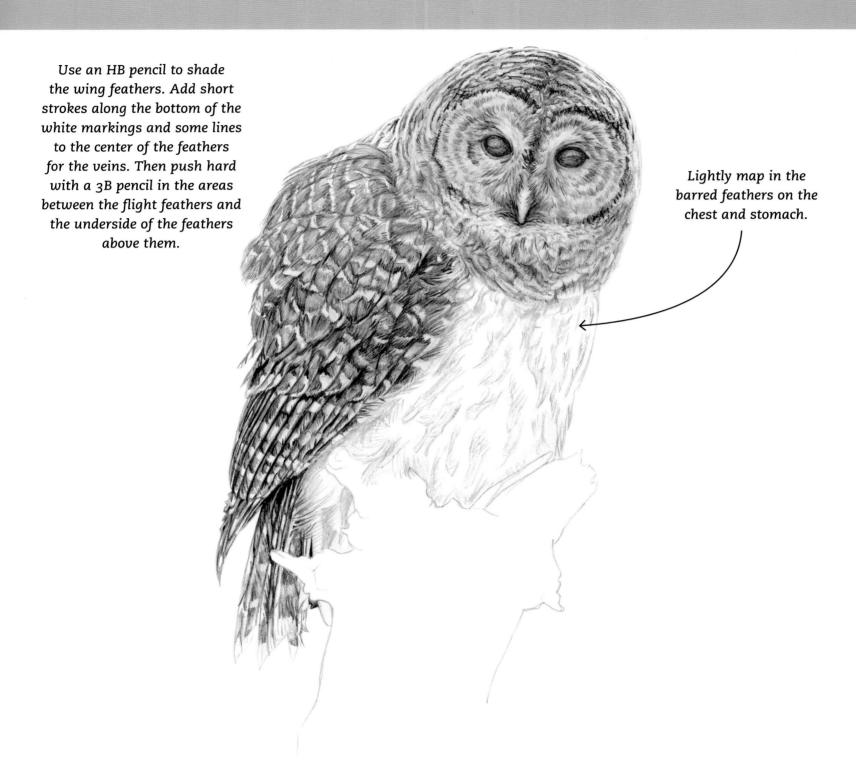

Use an HB pencil to shade the wing feathers. Add short strokes along the bottom of the white markings and some lines to the center of the feathers for the veins. Then push hard with a 3B pencil in the areas between the flight feathers and the underside of the feathers above them.

Lightly map in the barred feathers on the chest and stomach.

OVERLAPPING FEATHERS

Overlapping feathers are often found on the neck, back, chest, and shoulders. They give the impression of a bird's volume, and rendering them realistically requires honing some skills in drawing negative space. The focus isn't on drawing the feathers, so much as the space between them.

Using an H pencil, shade in the dark areas between the feathers. Make sure your pencil strokes follow the direction of the feather barbs.

Use a B pencil to deepen the dark values, pushing the deepest darks where the shadows appear furthest back. Add more light and midtones to the top of the feather. Then give the edges of the feathers some finer detail.

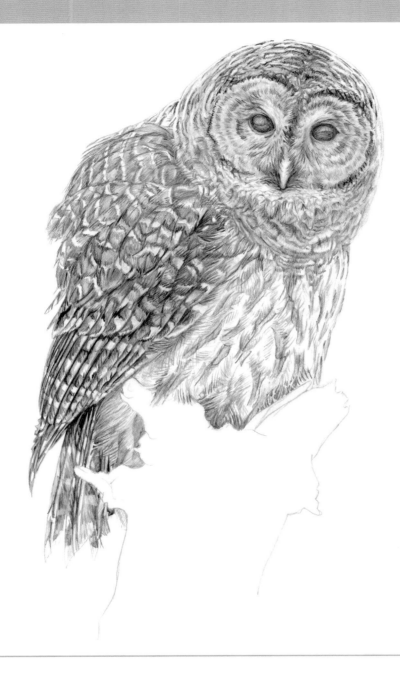

Shade the chest feathers with the HB pencil. Switch to a 2H pencil and finish lightly shading the barred feathers, leaving the top edges white. Add parallel strokes to suggest the textured edge of the white feathers under the tail, along the bottom of the bird, and the edge where the stomach meets the wing. Finally, with a dark stroke from the HB pencil, create a vein running through the center of several darker chest feathers.

BARK

Bark is a common element in bird drawings. This example of cedar tree bark shows the process you can follow to draw any kind of bark.

 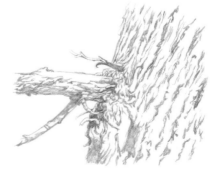 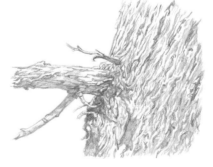

Use an H pencil to sketch a rough outline.

With a B pencil use short, close strokes to create dark shadow areas.

Use a 2H pencil to add texture and shading. Make long, curved lines for elongated sections of peeling bark and fill in around these lines with very fine, close strokes to establish a light gray midtone.

With a 2B and 4B pencil, darken shadows. With multiple levels of shading that range in value, you will have enough layers of texture and light to bring realism to the bark.

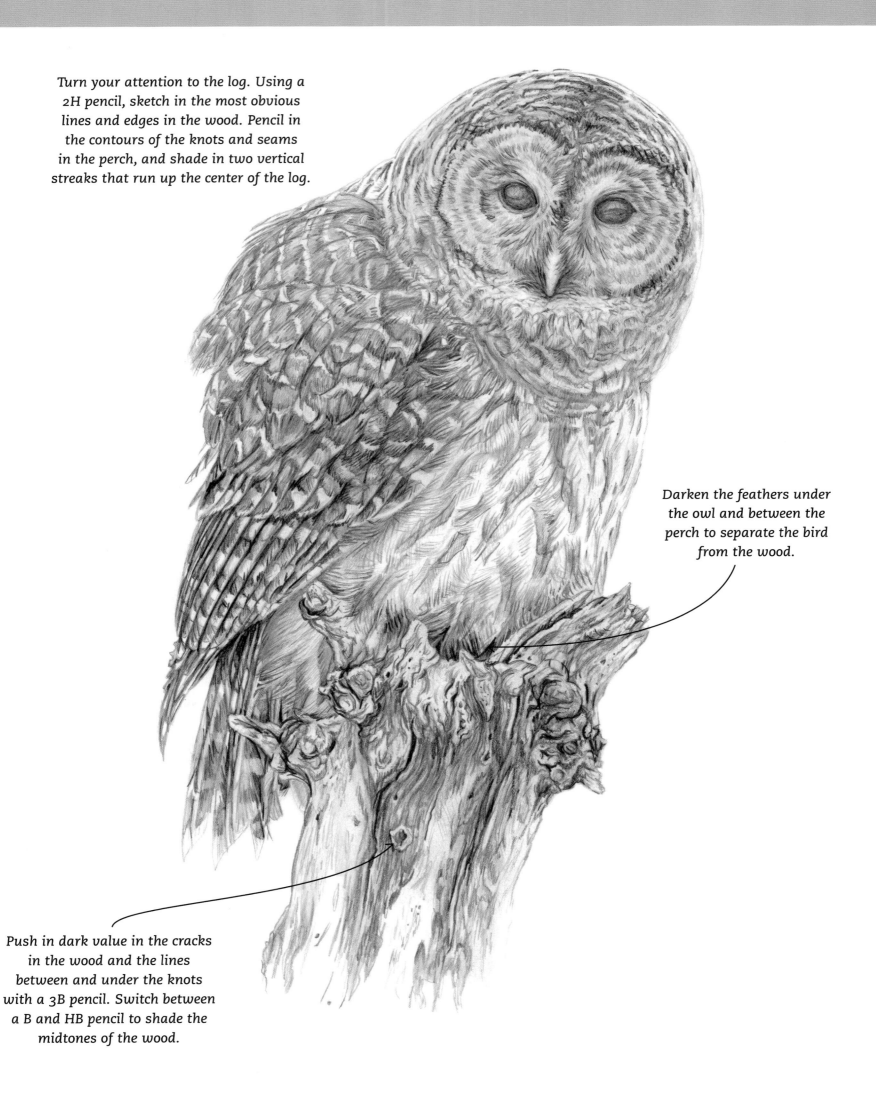

Turn your attention to the log. Using a 2H pencil, sketch in the most obvious lines and edges in the wood. Pencil in the contours of the knots and seams in the perch, and shade in two vertical streaks that run up the center of the log.

Darken the feathers under the owl and between the perch to separate the bird from the wood.

Push in dark value in the cracks in the wood and the lines between and under the knots with a 3B pencil. Switch between a B and HB pencil to shade the midtones of the wood.

Add more value under and between the feathers below the chin and extend the darks from the front of the neck into the dark "swoop" that runs over the owl's chest. Then add some more extra dark values under the edges of the feathers on the front of the neck and where the tail feathers meet the fluffy rump feathers.

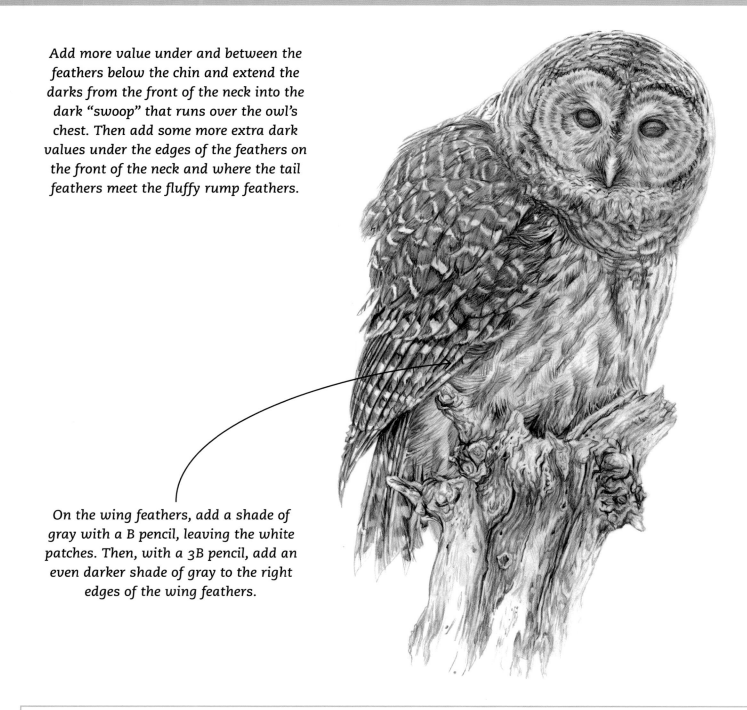

On the wing feathers, add a shade of gray with a B pencil, leaving the white patches. Then, with a 3B pencil, add an even darker shade of gray to the right edges of the wing feathers.

DOWNY FEATHERS

Downy, hair-like feathers are a common bird attribute. Most birds have downy feathers somewhere close to their body to stay warm. Others, such as ducklings and kiwis, are covered by such feathers.

Draw long, curved strokes, leaving space between some lines, and make other lines closer together. A variety of curves, directions, and darkness in the lines establishes realistic hair-like feathers.

Follow the previous strokes with a softer pencil. Varying the lines' thickness and darkness gives the feathers a natural appearance. Leave some areas of white and some lighter strokes visible, so there is variation in value. Use the sharp edge of an eraser to add some light streaks for highlights.

A dark background is appropriate for this nocturnal bird and will add drama. Push hard with the 4B pencil all around the bird and perch, lightening the strokes as you move away from the owl. Fade out the edges with a blending stump.

Use the 4B pencil to darken the eyes.

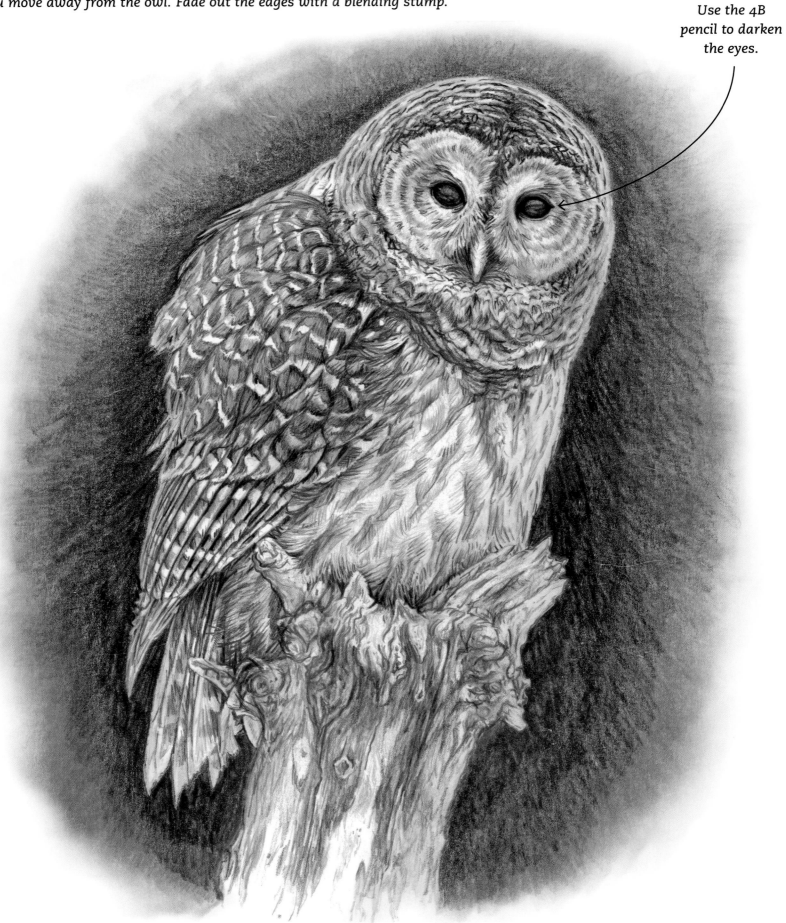

GREAT BLUE HERON

For this drawing of a great blue heron, I picked a photo with a pose that I felt captured the essence of the bird. However, I wasn't happy with how it seemed to float in space on the log and decided to add a watery background. I noted that the light source was coming from the right of the heron. When shooting a photo of dappled water, I made sure the light source came from the same direction.

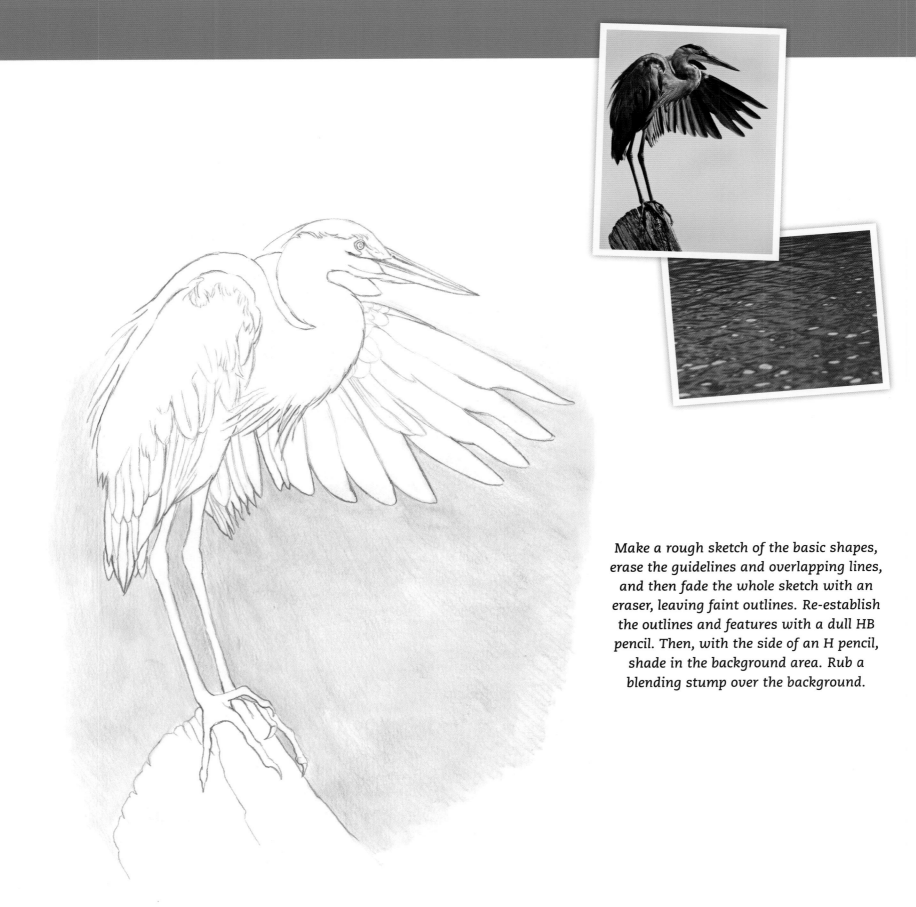

Make a rough sketch of the basic shapes, erase the guidelines and overlapping lines, and then fade the whole sketch with an eraser, leaving faint outlines. Re-establish the outlines and features with a dull HB pencil. Then, with the side of an H pencil, shade in the background area. Rub a blending stump over the background.

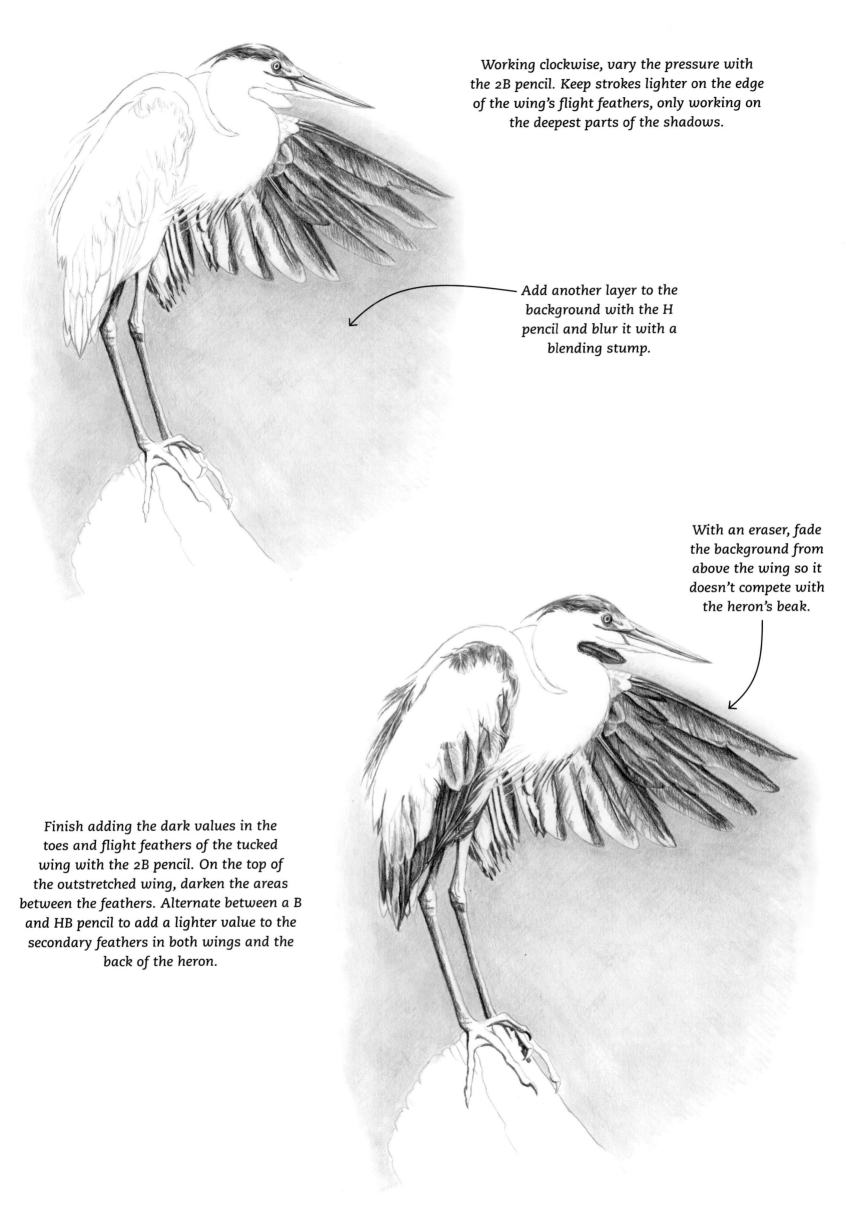

Working clockwise, vary the pressure with the 2B pencil. Keep strokes lighter on the edge of the wing's flight feathers, only working on the deepest parts of the shadows.

Add another layer to the background with the H pencil and blur it with a blending stump.

With an eraser, fade the background from above the wing so it doesn't compete with the heron's beak.

Finish adding the dark values in the toes and flight feathers of the tucked wing with the 2B pencil. On the top of the outstretched wing, darken the areas between the feathers. Alternate between a B and HB pencil to add a lighter value to the secondary feathers in both wings and the back of the heron.

On the neck and chest, use short strokes with a 2H pencil, often bunching them together to suggest clumps of feathers. Then draw horizontal lines across the toes and shins to show the plated look of the scales.

On the outstretched wing, add a shadow with the B pencil on the darkest parts and use a blending stump to fade out some of the pencil strokes and make the feathers look "softer."

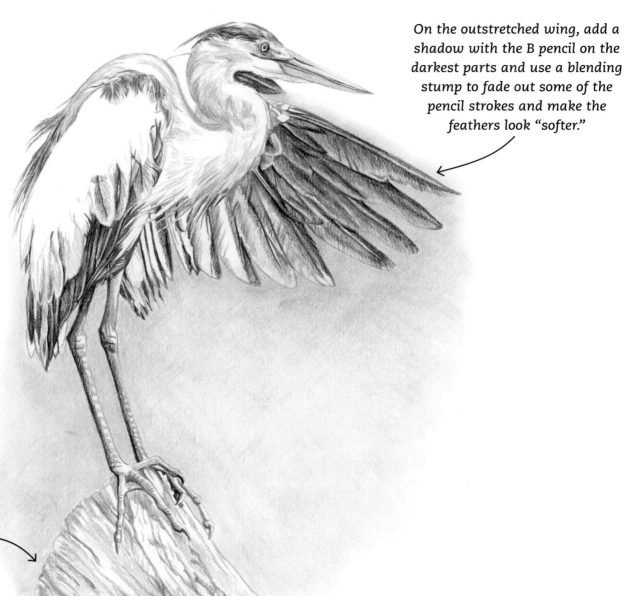

Use an H pencil to establish the deeper grooves on the log, creating a framework that shows the direction of the wood's grain. Then add light shading with a 2H pencil.

FLIGHT FEATHERS

Flight feathers are the elongated feathers that allow a bird to fly. They protrude from smaller feathers that insulate the bird's shoulder and wing. In this example, an indigo bunting's feathers are outstretched.

Sketch the outline of the flight feathers and the "bushier" feathers with an HB. Extend the swooping lines of the flight feathers, complete with the vein that runs through each, anchoring the feathers' barbs.

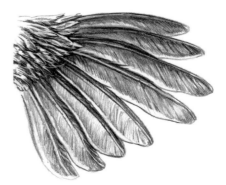

With a B pencil, shade the deepest darks. Use fine strokes to shade the feathers, blending with a tortillon and wiping away some graphite with a kneaded eraser. Add deep value to the spaces between the bushy feathers and add lines throughout with a lighter pencil.

Use an H pencil to begin adding texture to the stringy clumps of feathers on the tucked wing. Start with short strokes and shade the wing evenly to establish the gray color. Add some darker areas between feathers and some long lines to suggest the occasional out-of-place feather.

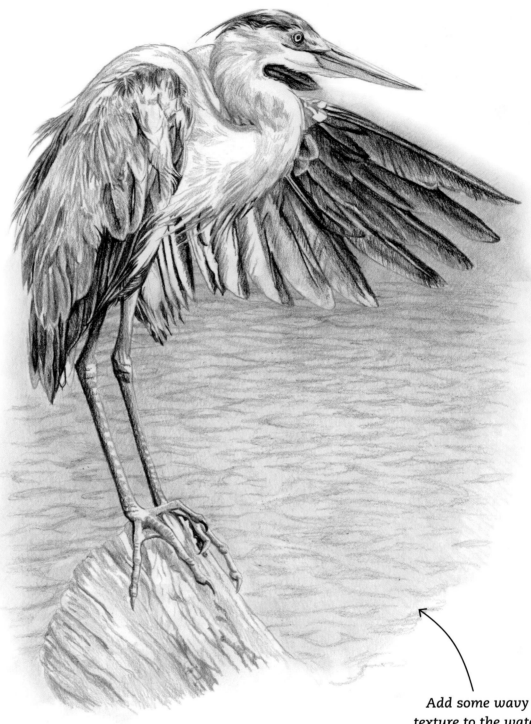

Add some wavy texture to the water with a 2H pencil, keeping the strokes light and close.

Don't darken the water to the same value level of the heron. Keep it light and vague in detail. The heron is the focus, while the water serves to ground the illustration.

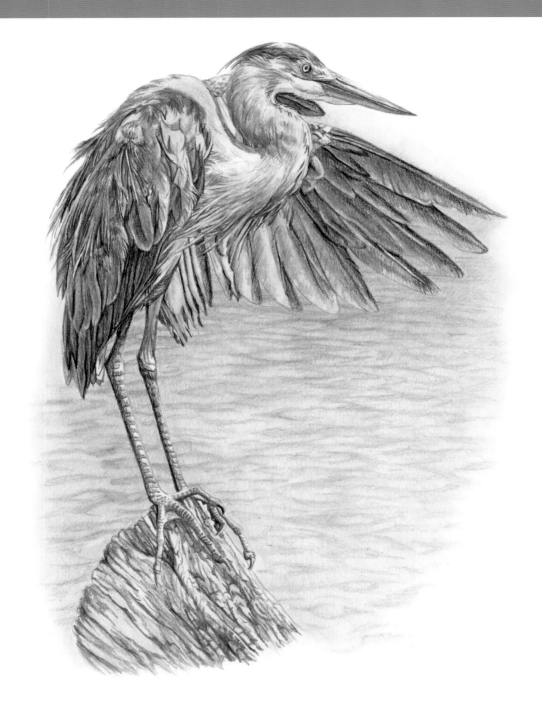

Go over large areas of the bird with the B pencil, and then go back to reinstate the darks in the feather texture. Add a little texture to the shoulder behind the head and on the grooves of the wood.

FEET

A bird's foot often appears at odds with the rest of its body. Scaly and leathery with sharp nails, it seems a harsh contrast to the glossy and fluffy body resting on top. Like beaks, feet vary widely from bird to bird, but there are commonalities to lay a good groundwork. This example is of a duck's foot, as it consists of several interesting shapes and textures.

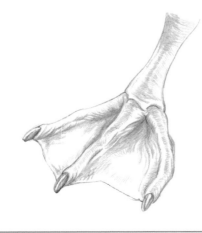

Sketch the shape of the leg, toes, webbing, and nails. Using an HB pencil, shade down the leg and toes, and darken the toenails. Leave some areas white for highlights.

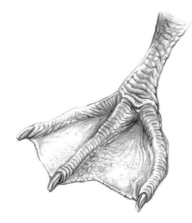

With a B pencil, draw lines for the scaly edges of the toes and ankle, draw miniscule circular scales on the webbing. Finally, add some dark strokes throughout.

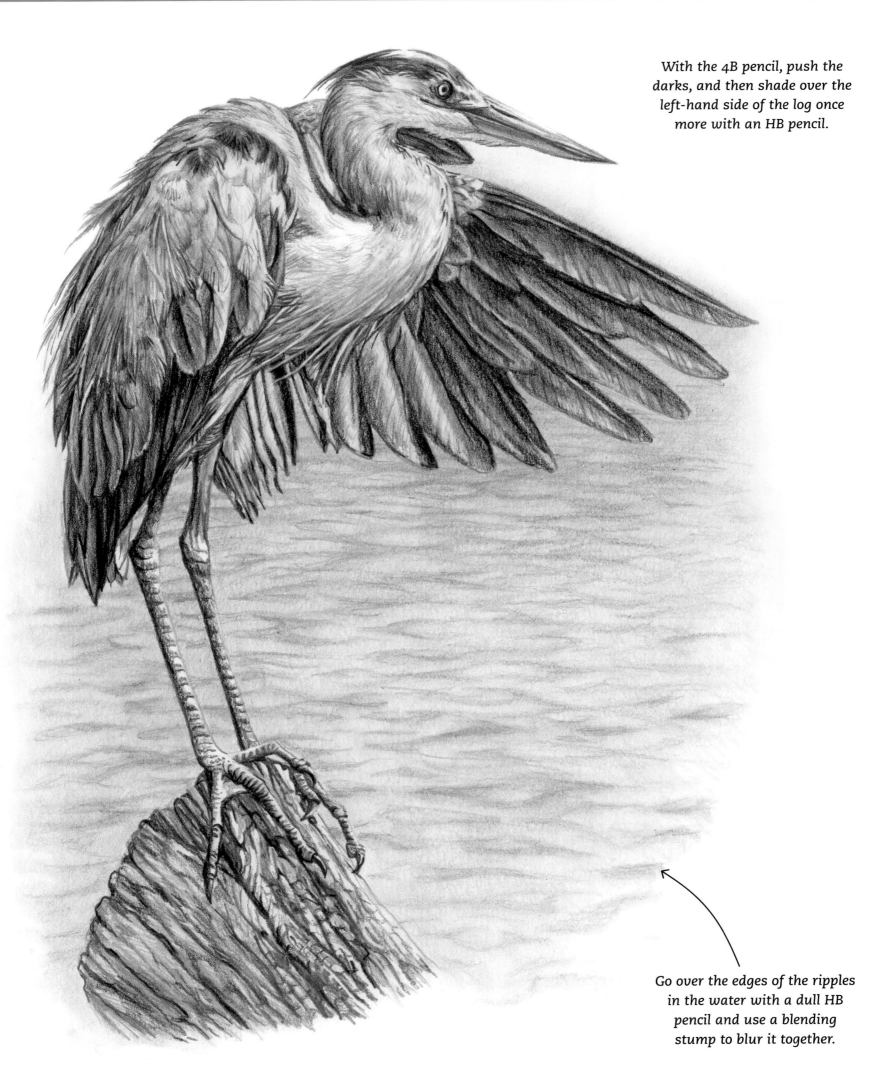

With the 4B pencil, push the darks, and then shade over the left-hand side of the log once more with an HB pencil.

Go over the edges of the ripples in the water with a dull HB pencil and use a blending stump to blur it together.

RUBY-THROATED HUMMINGBIRD

In this drawing, I want to show the iconic image of a hummingbird approaching a flower for a sip of nectar. There's no flower in my reference photo, but I decide to use a columbine bloom.

Start with a sketch, and then erase the guidelines you used to establish the basic shapes.

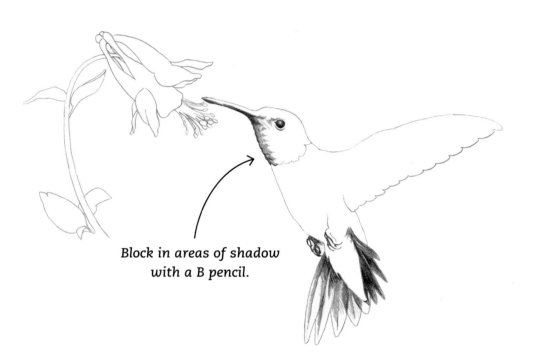

Block in areas of shadow with a B pencil.

Add light shading on the tail and around the head, leaving a ring around the eye and a white spot behind it.

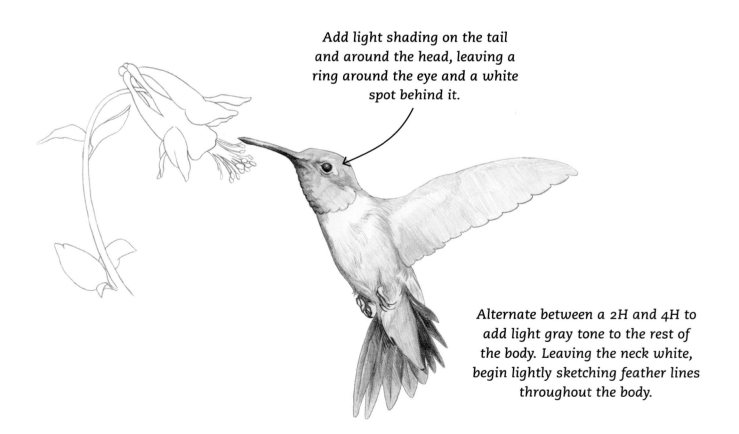

Alternate between a 2H and 4H to add light gray tone to the rest of the body. Leaving the neck white, begin lightly sketching feather lines throughout the body.

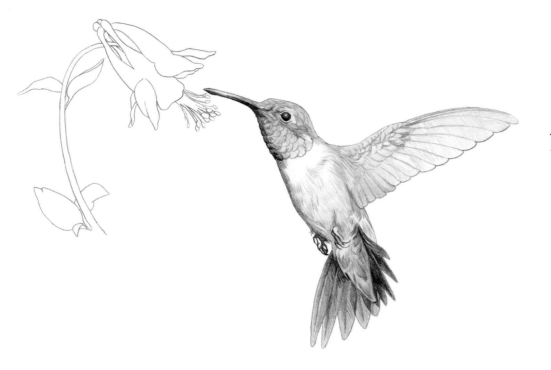

There are a lot of details in the feathers; map them out with a 0.5mm B mechanical pencil. Add a few strokes on the edges of the tail feathers with a B pencil for depth.

Add details throughout the hummingbird with a B pencil. Return to the primary tail feathers with a 4B pencil and push the darks harder.

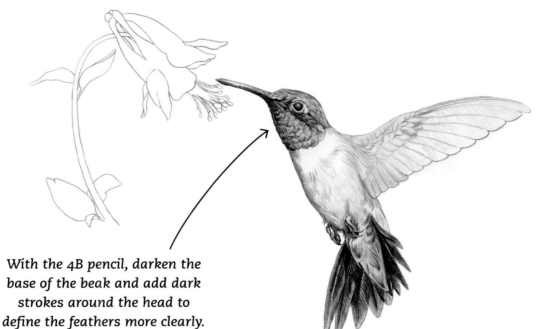

With the 4B pencil, darken the base of the beak and add dark strokes around the head to define the feathers more clearly.

Lightly sketch in the mid-range values on the columbine.

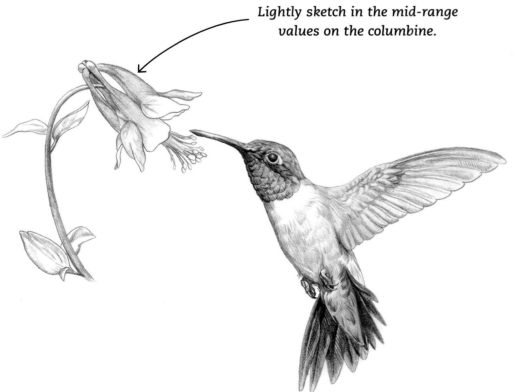

With an HB pencil, work in some mid-range values in the bird's wing and stomach and use short strokes along the belly feathers to establish layers of texture. Then add some shading throughout the hummingbird.

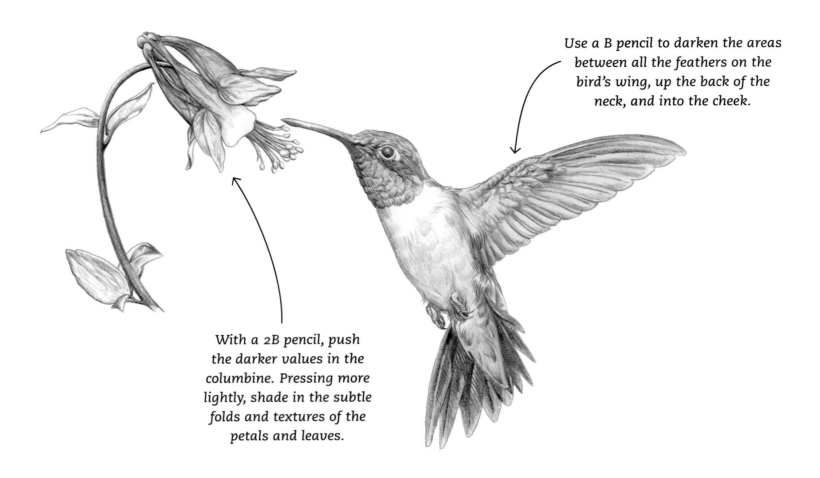

Use a B pencil to darken the areas between all the feathers on the bird's wing, up the back of the neck, and into the cheek.

With a 2B pencil, push the darker values in the columbine. Pressing more lightly, shade in the subtle folds and textures of the petals and leaves.

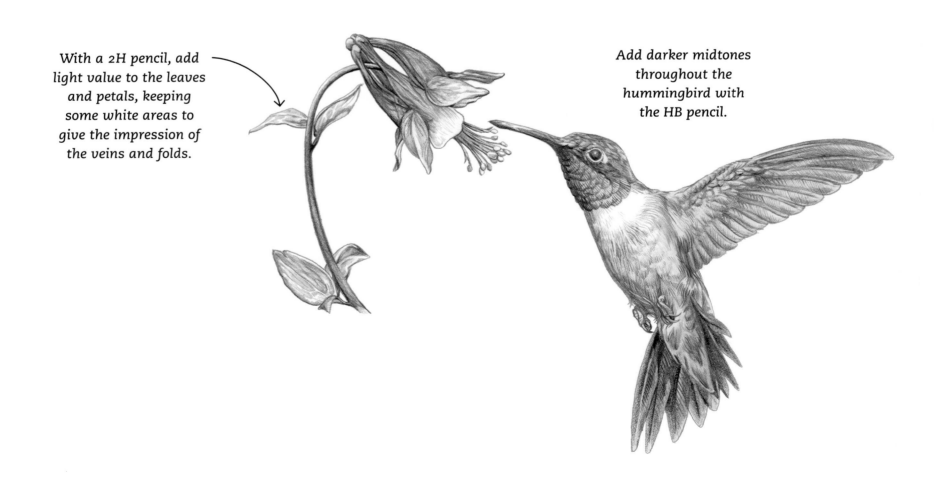

With a 2H pencil, add light value to the leaves and petals, keeping some white areas to give the impression of the veins and folds.

Add darker midtones throughout the hummingbird with the HB pencil.

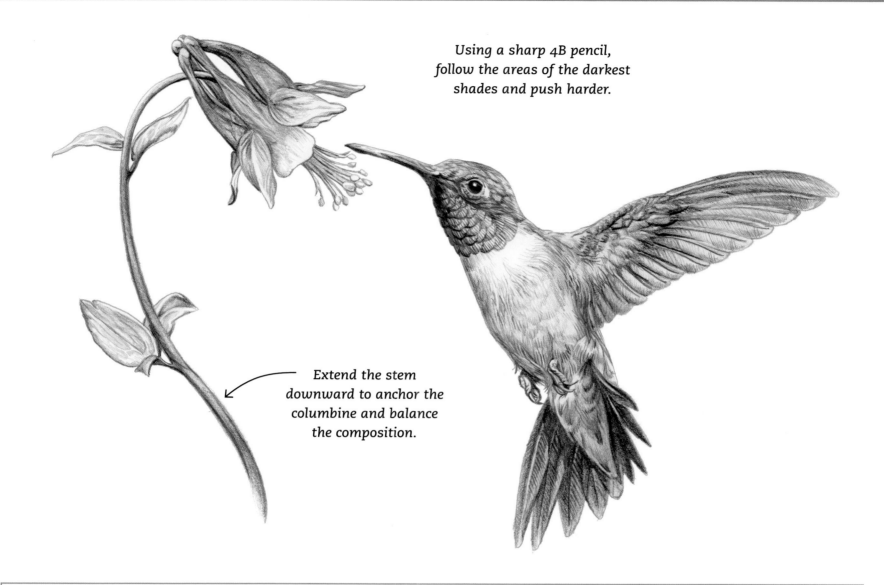

Using a sharp 4B pencil, follow the areas of the darkest shades and push harder.

Extend the stem downward to anchor the columbine and balance the composition.

BEAKS

The beak is often the focal point of an illustration and a defining characteristic of the bird species. There are so many variations on the beak that it would be impossible to address them all here. However, there are some general principles you can follow for most birds. This example shows the beak of a northern cardinal.

Draw the basic shape of the beak. The top and bottom bill are never mirror images of each other.

Use fine, tight lines to convey the hard, smooth texture. Pay close attention to your reference material and look for small reflections and shadows on the beak. Add feathers with a B pencil. Then, to give the beak an even glossier appearance, smooth out some of the lines with a blending stump.

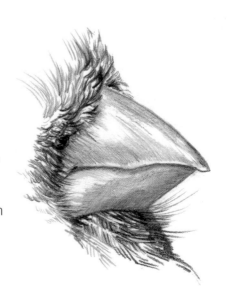

GREY PARROT

The grey parrot is one of the smartest animals in the world, capable of simple math, extensive language skills, and a myriad of emotions. Considering it is a creature that practically anthropomorphizes itself, I thought a portrait of this mischievous bird would be a good way to capture its personality, as well as provide an opportunity to study its features up close.

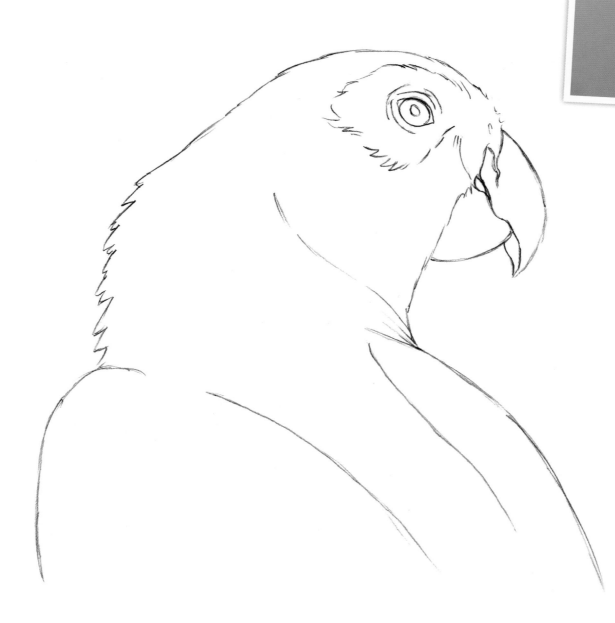

Create a sketch with some basic components of texture, including the rough edge of the feathers at the back of the neck, wavy lines feeding into the beak, and a feathered ring around the eye.

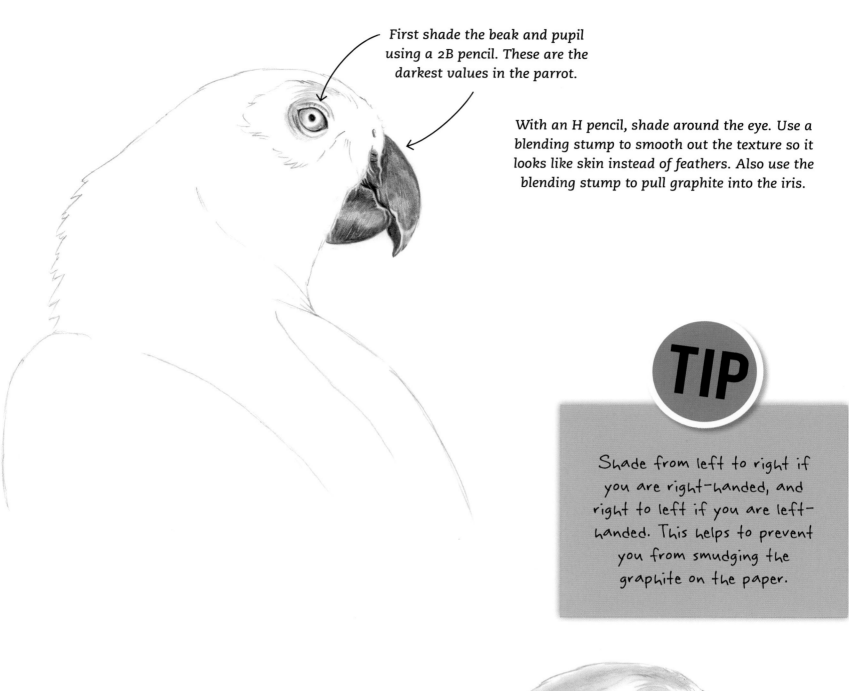

First shade the beak and pupil using a 2B pencil. These are the darkest values in the parrot.

With an H pencil, shade around the eye. Use a blending stump to smooth out the texture so it looks like skin instead of feathers. Also use the blending stump to pull graphite into the iris.

TIP

Shade from left to right if you are right-handed, and right to left if you are left-handed. This helps to prevent you from smudging the graphite on the paper.

Lay down solid gray tone on the body with an H pencil, avoiding the lightest areas and adding another layer where the shadows will be deepest.

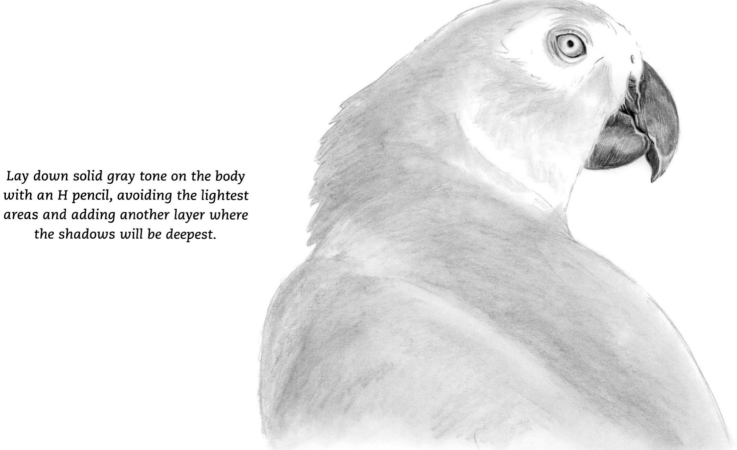

Lightly sketch in the outline of the feather pattern with a 2H pencil and work your way from the top down. Then switch to an HB pencil and begin to darken areas between feathers to establish depth and texture.

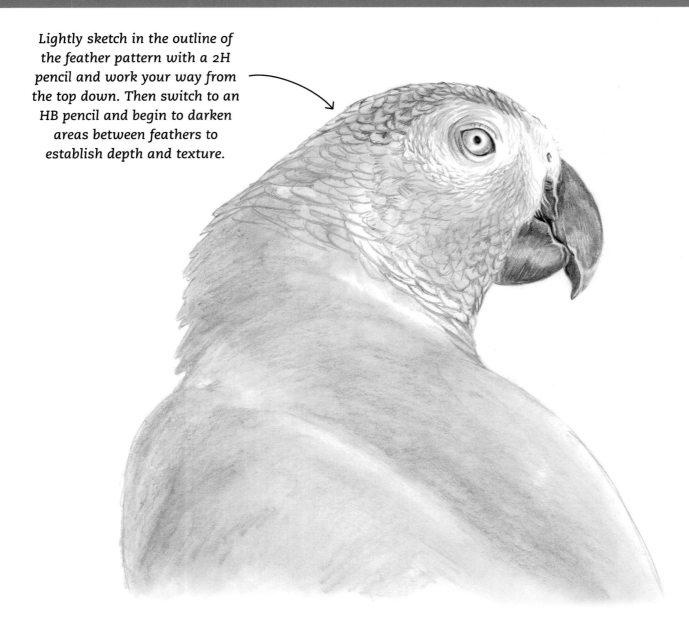

EYES

Besides the beak, the eye of a bird is the most common focal point of a drawing. Whether they are dark beads, large disks, or have a piercing pupil, birds' eyes are always striking. A goshawk is the model in this example.

Draw the basic shapes with an HB pencil. Use the H pencil to add curved strokes for the soft feathers around the eye. Add the most strokes close to the eye and the brow ridge, where the shadows are.

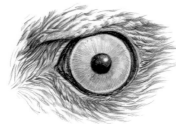

Shade the pupil and the ring around the eye with a 2B pencil, leaving highlights where light reflects. Then use a B pencil to add short strokes on the underside of feathers for depth. For the iris, switch to an H pencil and use fine strokes, starting at the pupil and pulling toward the edge.

Continue adding the feathers with the 2H and HB pencils, paying close attention to your reference image.

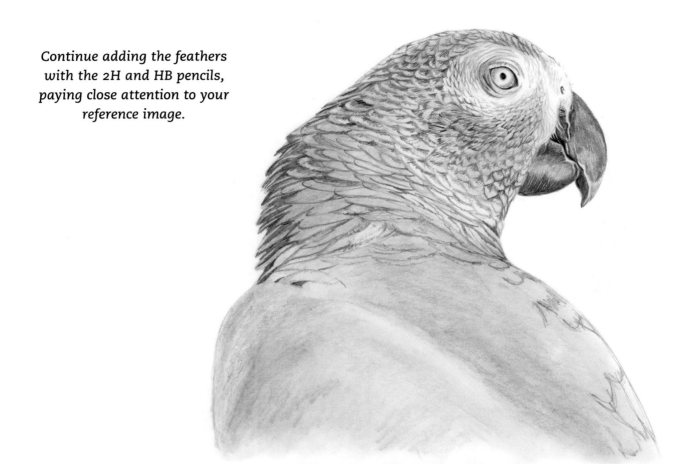

With a 2B pencil, add a few areas of darkness and deepen some shadowed areas, including the shadows on the fluffed-up neck feathers.

Finish mapping out the feathers. Mark the feathers that have a vein running down the middle with a line.

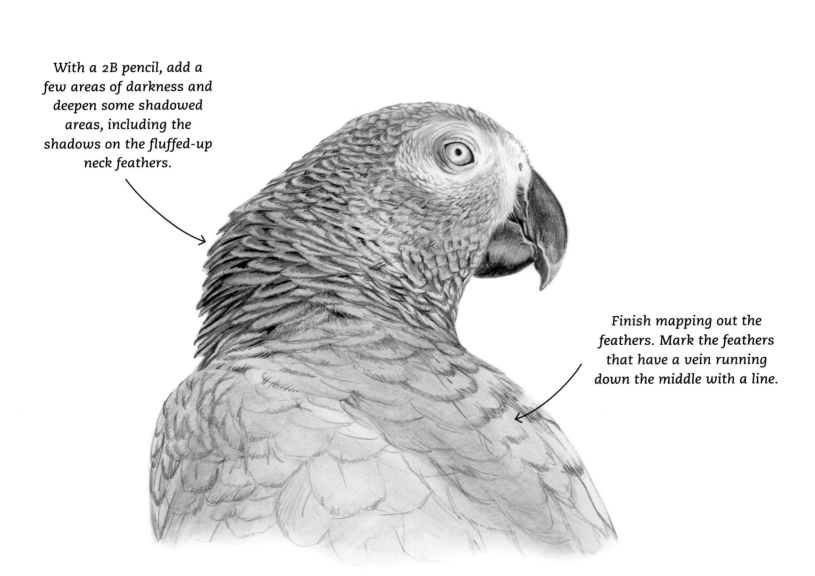

Continue adding dark values. Fade any too-dark areas with an eraser and re-establish the appropriate dark areas with a dull B pencil.

With the HB pencil, sketch in some detail in the feathers and smooth out some of your strokes with a blending stump.

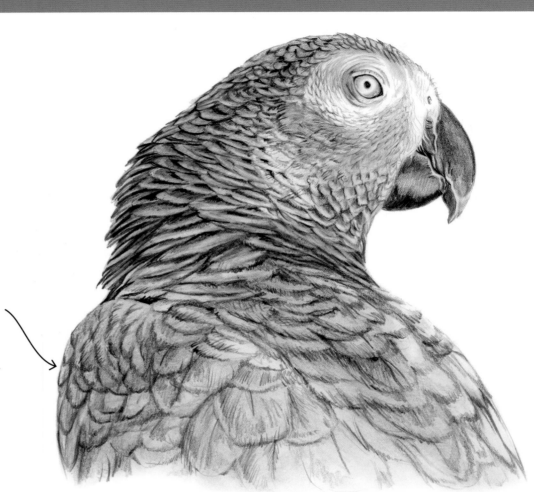

Go back with the HB to the cheek feathers and darken the lines.

Continue shading the back and wings, leaving some of the feathers' right edges alone. Switch to a mechanical H pencil and alternately add fine lines to the edges and dark lines to the middle of the feathers. Then smooth some of the detail.

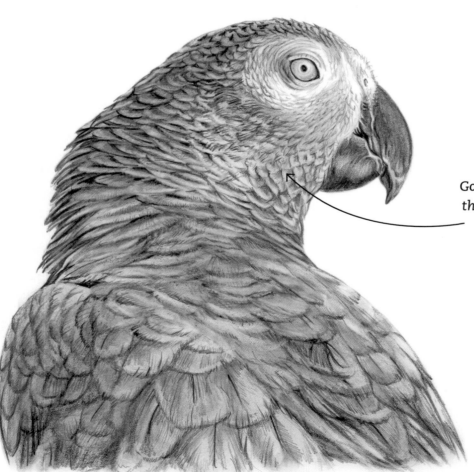

Drawing birds can seem daunting, with so many fine details to capture. Don't be discouraged. Not every line needs to be drawn to give your drawing a lifelike appearance.

With a B pencil, add little accent strokes to the skin texture around the nose and eye.

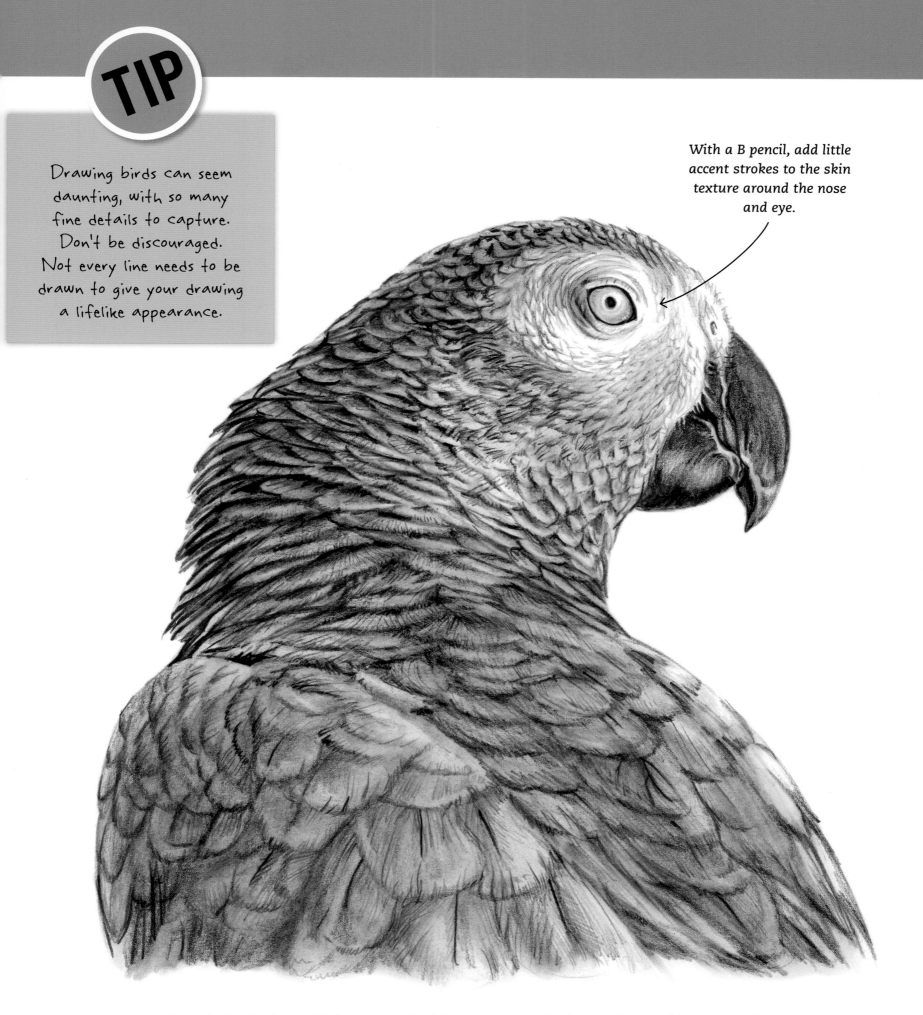

To push the shadows a little more, go back in once more to darken the darks with a 4B pencil. Then blend some of the shadows along the shoulders and back with a blending stump. Using a sharp H pencil, create a little more feather detail.

PILEATED WOODPECKER

While this scene of a pileated woodpecker with its young is cute, I really want to focus on the adult woodpecker. I decide to eliminate the babies and draw my bird perched on a dead birch tree at the edge of a rotted out-hole.

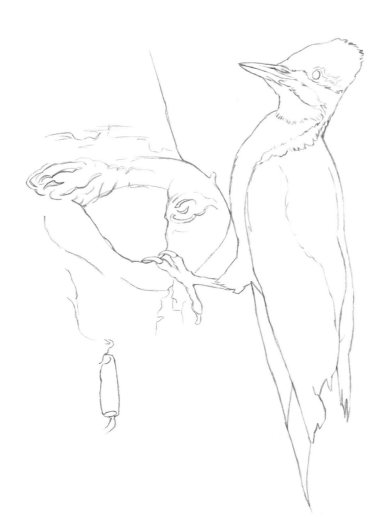

After mapping in the basic shapes, switch to an HB pencil to refine them. While adding some texture and detail to the lines, erase any guidelines you used to create the sketch.

Pressing very lightly with the edge of a blunt B pencil, shade in the bird and tree, leaving the lightest areas white. Then use a blending stump to smooth out the pencil strokes in most places.

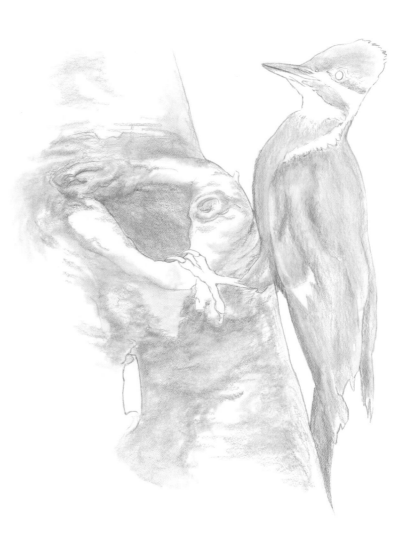

With a 2B pencil, darken the beak, tail, and mask around the eye. Shade the tail and the center of the toenails. Switching to a 4B pencil, push deeper darks on the woodpecker's underside and face and the hole of the birch tree. Using an H pencil and short, backward-curving strokes, add the forehead feathers. Also add rows of short strokes along the cheek, triangular patterns along the upper chest, and the border between the white and darker feathers.

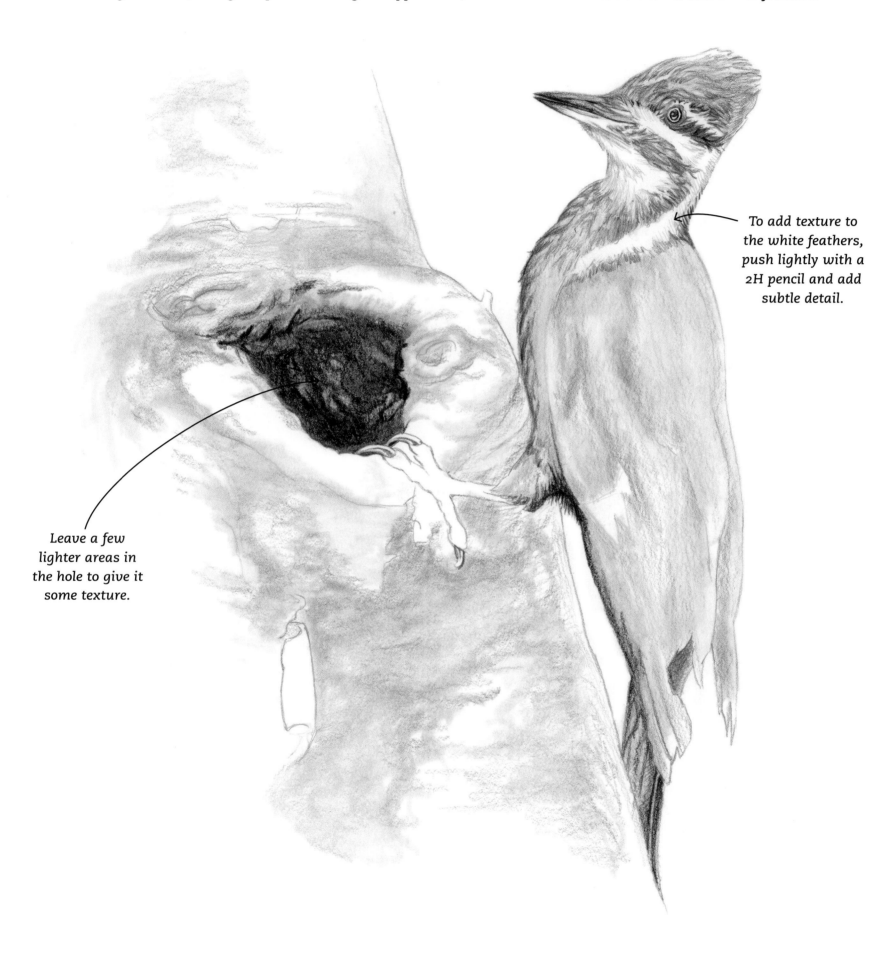

To add texture to the white feathers, push lightly with a 2H pencil and add subtle detail.

Leave a few lighter areas in the hole to give it some texture.

LEAFY TREES

Leafy trees are home to countless bird species and are a common backdrop in a backyard or in a forest. See the maple branch below to practice drawing part of a leafy tree.

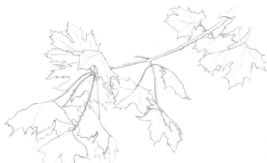 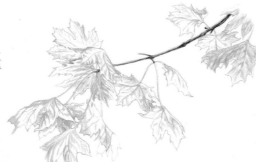

After crafting the shape of the branch, draw the basic shapes of the leaves. Use light pressure with an H or HB pencil.

Map in the shading on the leaves, using light, short strokes with the side of an HB pencil. Use a 2B pencil to give the smooth bark of the twig a bolder presence.

Go back with a B pencil and deepen the dark areas. Add variance to the shades for interest. For finer detail in the grooves and veins, use a lighter pencil.

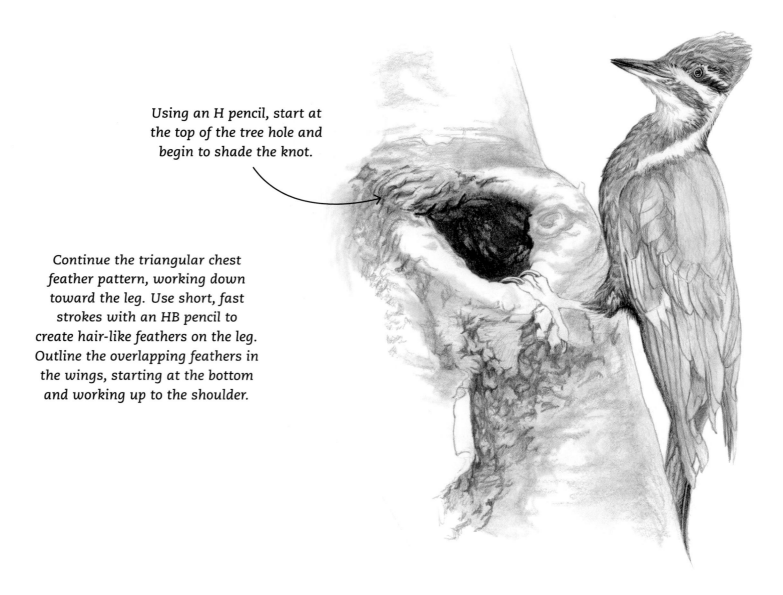

Using an H pencil, start at the top of the tree hole and begin to shade the knot.

Continue the triangular chest feather pattern, working down toward the leg. Use short, fast strokes with an HB pencil to create hair-like feathers on the leg. Outline the overlapping feathers in the wings, starting at the bottom and working up to the shoulder.

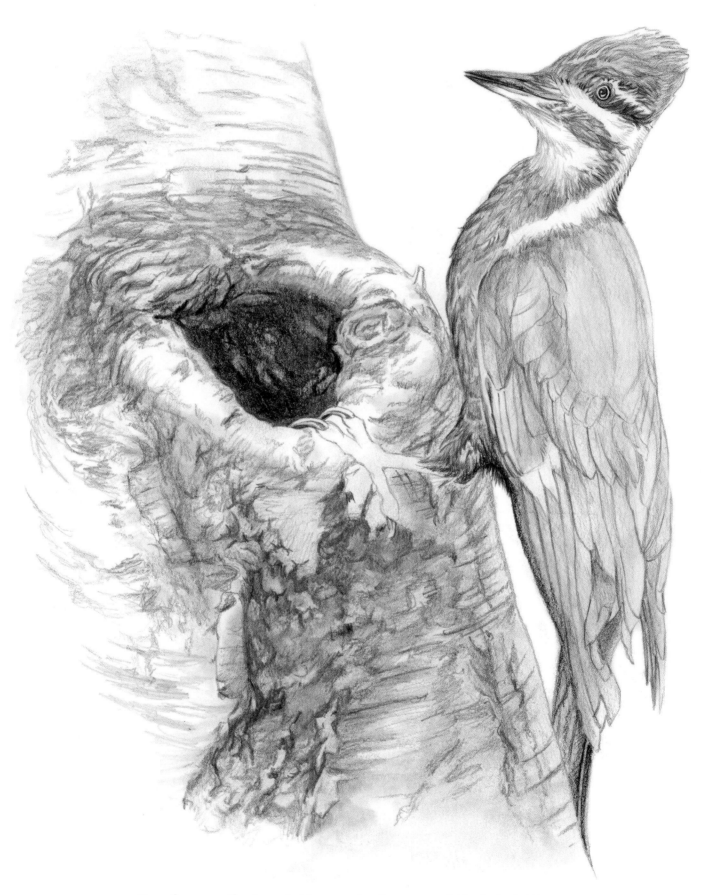

Now focus on the tree. Add more shading around the hole, letting abstract shapes peek out, and add series of horizontal lines along the right edge of the trunk. Change to a 3H pencil and add subtle line and shading detail throughout the unrotted bark. Then smooth out some of the boundaries between line strokes with a blending stump.

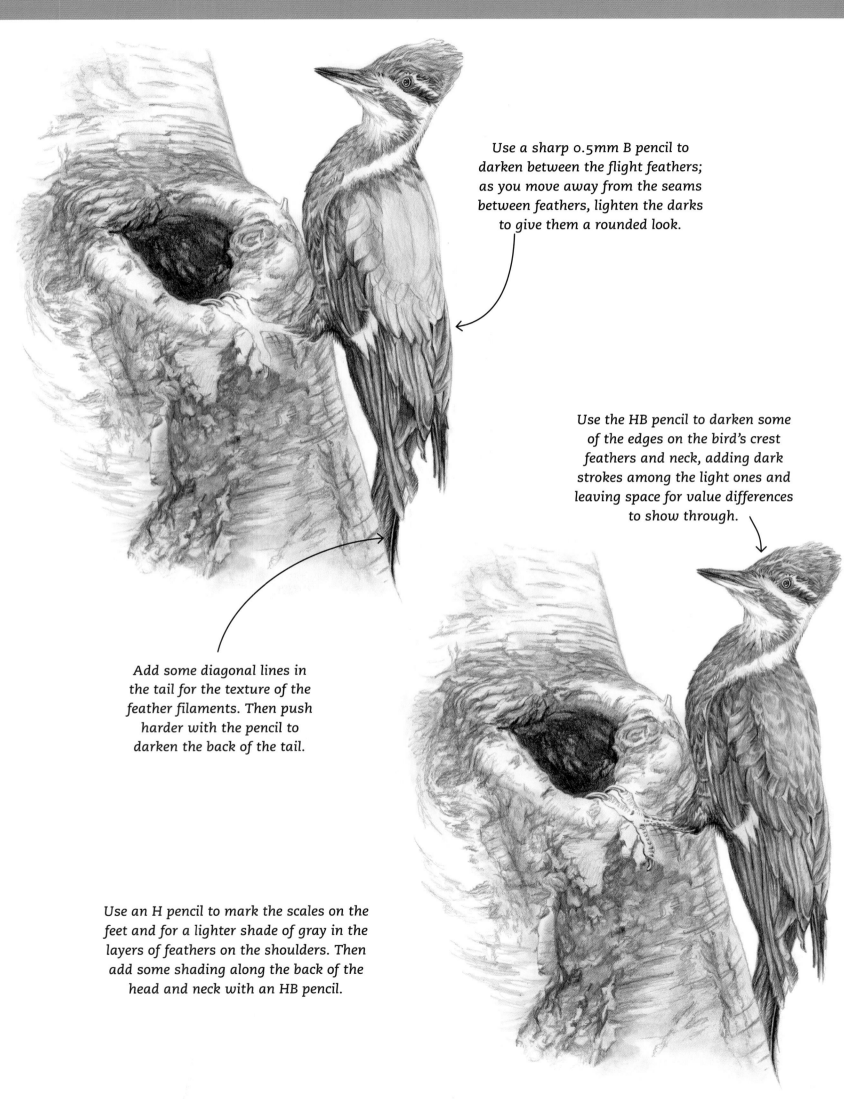

Use a sharp 0.5mm B pencil to darken between the flight feathers; as you move away from the seams between feathers, lighten the darks to give them a rounded look.

Use the HB pencil to darken some of the edges on the bird's crest feathers and neck, adding dark strokes among the light ones and leaving space for value differences to show through.

Add some diagonal lines in the tail for the texture of the feather filaments. Then push harder with the pencil to darken the back of the tail.

Use an H pencil to mark the scales on the feet and for a lighter shade of gray in the layers of feathers on the shoulders. Then add some shading along the back of the head and neck with an HB pencil.

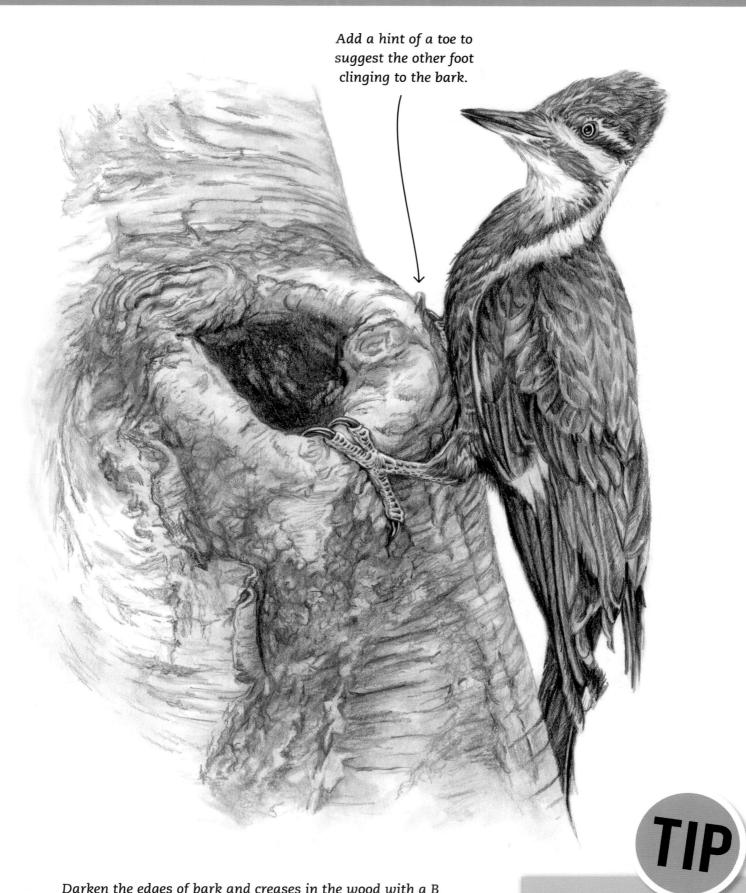

Add a hint of a toe to suggest the other foot clinging to the bark.

Darken the edges of bark and creases in the wood with a B pencil and smudge the values. Go back and add a few more detail lines with a light 2H pencil. To make the woodpecker pop against the tree trunk, darken areas on and around the foot, throughout the woodpecker, and the shadow between the bird and tree. Use the edge of an eraser along the top of the shin to help the foot pop out against the dark tree bark.

TIP

If the bird seems to be competing with the tree for the focal point, use a kneaded eraser to lift some graphite from the darkest areas of the trunk.

BLACK-CAPPED CHICKADEES

Black-capped chickadees are busy, sociable birds. They never seem to be alone or sit still for long. I found multiple reference photos of chickadees in various poses and angles. To accurately portray the tree branch and all the birds flitting around it, be sure to carefully map the shapes you want to work with. I took a picture of a branch I thought would work well and used it for my model.

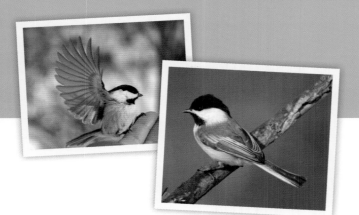

After sketching in the basic lines and shapes, refine the edges so they look more natural, erasing and replacing as you go.

Lightly shade the spruce needles with the edge of the H pencil.

With a sharp-tipped H pencil, add the outlines of each chickadee's wing and tail feathers, the edges of the birds' rumps, and lines through the beaks of the three perched birds. Shade the caps and chins of the chickadees.

With a B pencil, shade in the dark areas of the eyes, leaving a few white areas for reflections.

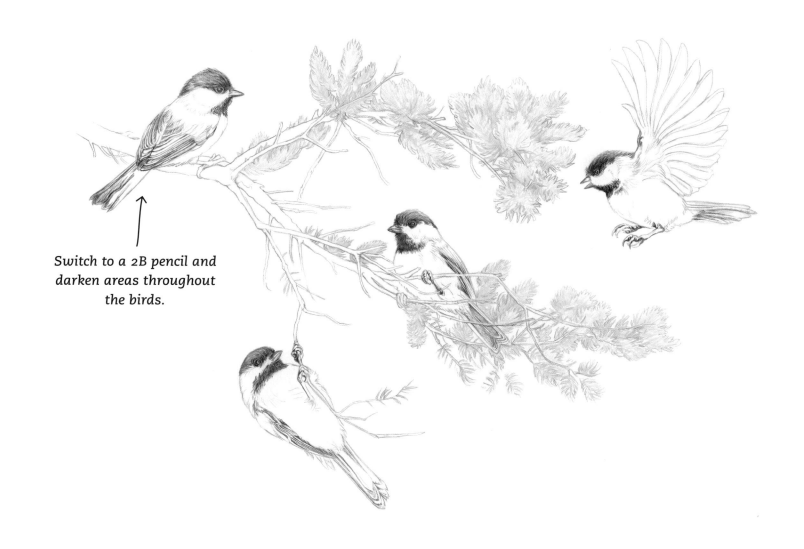

Switch to a 2B pencil and darken areas throughout the birds.

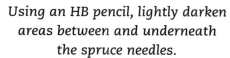

Using an HB pencil, lightly darken areas between and underneath the spruce needles.

Use a 2H pencil to lightly sketch in some value on the feathers and add a gray arch between the flight feathers and armpit feathers. Then lightly shade where the wing meets the body.

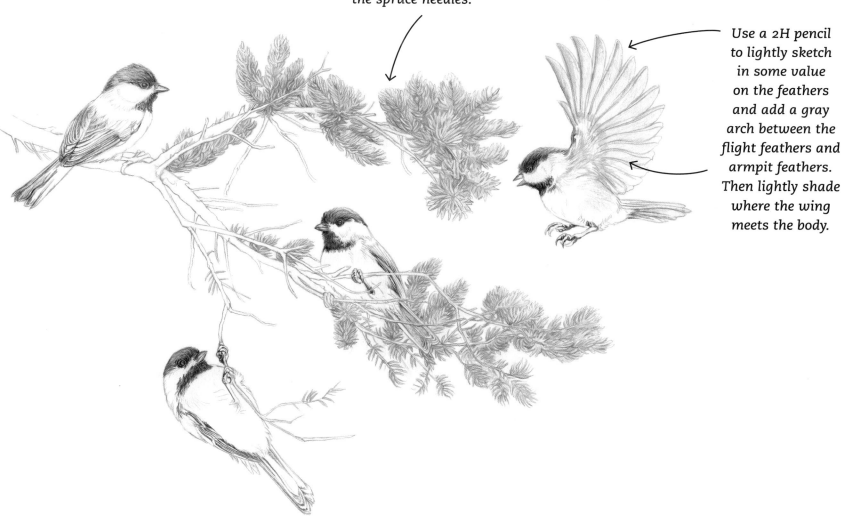

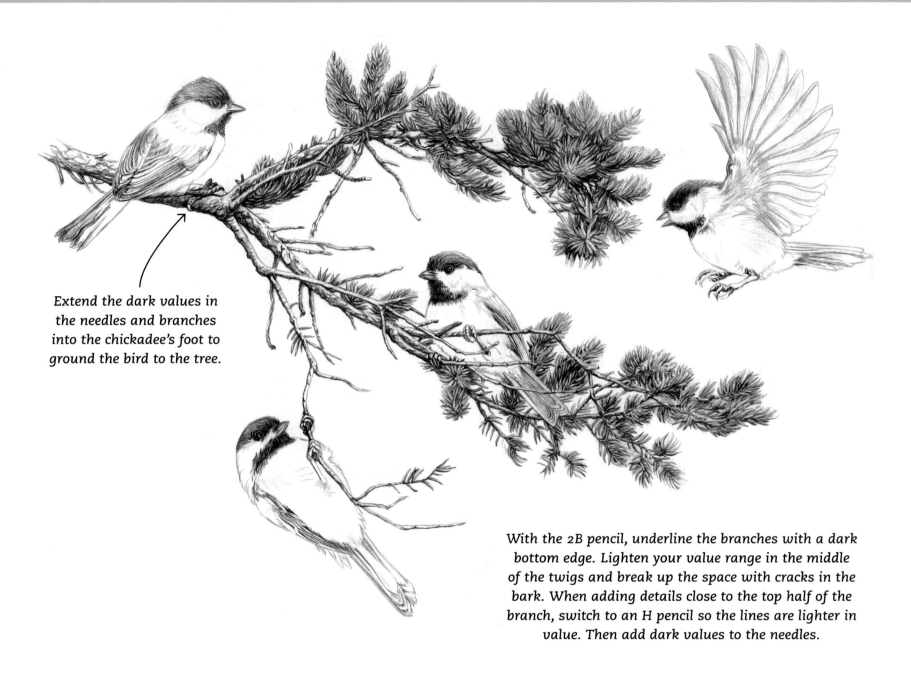

Extend the dark values in the needles and branches into the chickadee's foot to ground the bird to the tree.

With the 2B pencil, underline the branches with a dark bottom edge. Lighten your value range in the middle of the twigs and break up the space with cracks in the bark. When adding details close to the top half of the branch, switch to an H pencil so the lines are lighter in value. Then add dark values to the needles.

PINE NEEDLES

The dark shapes between the needles make the needles pop out, while the dark areas recede back. The areas in the center of the twig holding the needles and the bottom get the most attention with the darkest values. As you work your way up the needle clump, leave the top-most edges alone so they look as if some light is hitting them.

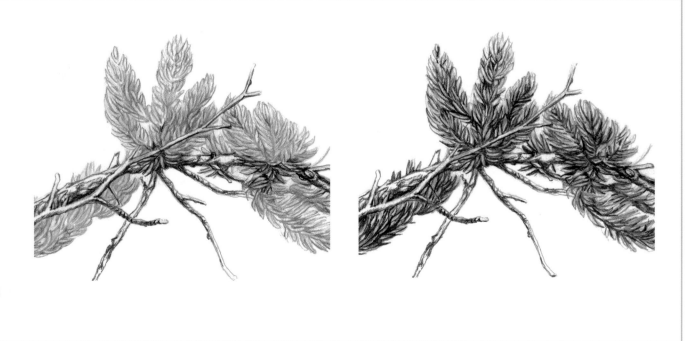

Add a hatched line pattern on the feathers of the
outstretched wing and a light shadow along the bottom
third of the flight feathers, leaving the ends white.
Then add curved detail lines on the body.

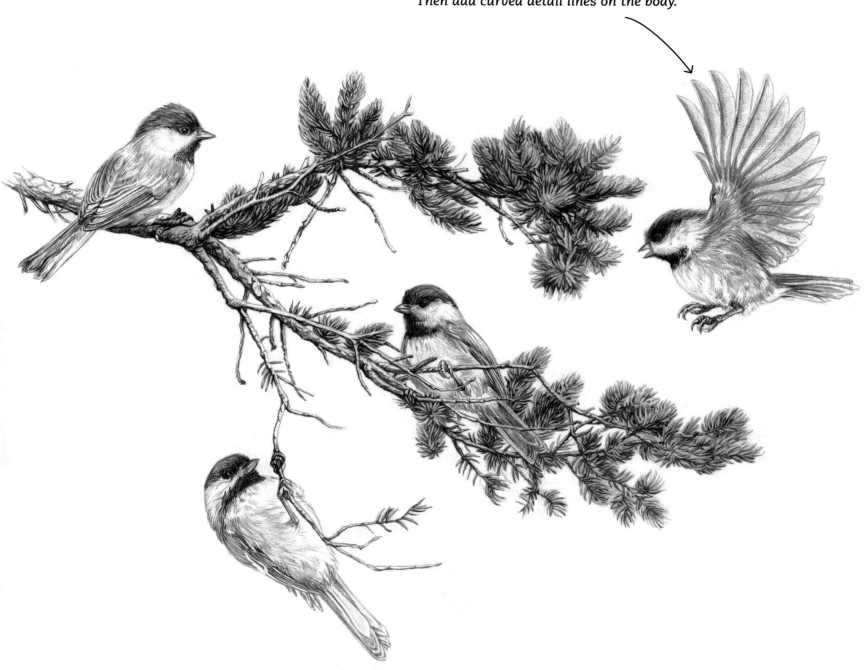

Add fine lines with a very sharp H pencil for hairlike texture in the body
feathers. For the birds' light undersides, use light strokes set further apart.
Add tiny fine lines for texture around the cheeks and eyes. Then apply
midtone values to the feet and shins, with darker areas around the claws,
scales, and on the bottom edges of the toes and legs.

With a 3B pencil, add darker strokes to the feathers and soften with a blending stump. Darken the shadow in the wing, and then use a rubber eraser to lighten areas in the middle of the feathers.

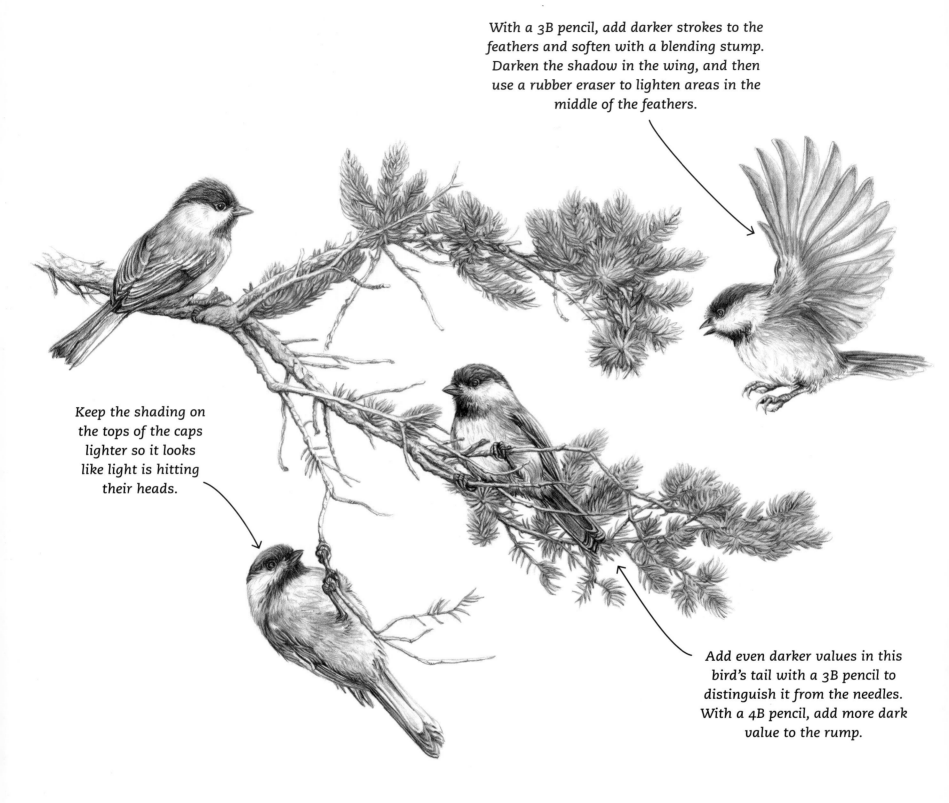

Keep the shading on the tops of the caps lighter so it looks like light is hitting their heads.

Add even darker values in this bird's tail with a 3B pencil to distinguish it from the needles. With a 4B pencil, add more dark value to the rump.

Darken the gray areas of the chickadees using a combination of darker strokes with an HB pencil, and then blend to soften. Switch to a 3B pencil to push the darks. Use a 4B pencil to push hard in the dark areas of the birds' caps and chins, using short strokes. Also darken the eyes, being careful to leave some small reflective areas.